GENDER GAP

Forma

edited by Laura Andreini

INDEX

FEMALE ARCHITECTURE

Cristina Giachi

Gender gap shows us the world of design seen by 20 female architects: projects that are very diverse in their style and inspiration. There is no doubt that many of us would prefer this title without the definition of gender, and that our definition as human beings, talented or not, was not constantly subject to being identified as women in our work activities, our roles in public life, and in our relationships. Unfortunately it has, and still does make a difference that an architect, a lawyer, a mayor, or a parent may be a woman, and for this reason, we are called women architects, lawyers, or mayors.

I am not sure if a common thread can be traced in the work and vision of these 20 architects: I will leave the task of reading between the lines to the experts in interpreting the narrative revealed in this exhibition, but I know that they have recognised themselves in a common collective body that vocalises and expresses their thoughts.

Nobody likes to be placed in a specific category identified simply as a percentage. Even more so for women who, throughout history, have suffered from greater discrimination. Women do not enjoy quotas of this type, just as they do not enjoy being a protected species like pandas in danger of extinction. But whether we like it or not, resistance still exists against changing the rules to suit both men and women, instead of men alone.

Quotas seem to still be a necessary remedy, at least for little longer. But this must not become a horizon or a prospect. This is not the objective we must aim for. The road towards equality has been a long one, and still presents fragile achievements that must be safeguarded by more enlightened men and women and directed towards the future.

But it has started, and much ground has been covered, even in those professions that are considered typically masculine.

The first important considerations on these topics were made in the context of an objectified and subjected female universe. In these initial reconstructions, the key to emancipation was employment, a means for independence and self-determination.

I am thinking of Simone de Beauvoir and her prodigious *The Second Sex*, which recently celebrated its 70th anniversary.

Today, in presenting the accomplished work of these 20 architects, I am pleased to note that despite certain statements made in the past by brave intellectual women on the subject of the female condition, these issues are

still dramatically true today in specific places and situations. All the same, we are witnessing a historic change in attitudes towards the role of women in authoritative positions, perfectly integrated in the professional sector.

It is a route that is embodied not only through belonging to a professional sector, but though the specific qualities and interpretations in which women express themselves. It is a route that presents itself, offering the fruits of personal reflection to be shared with the public.

For this, I am grateful to them all.

PARADIGMA
Il tavolo dell'architetto

GENDER GAP

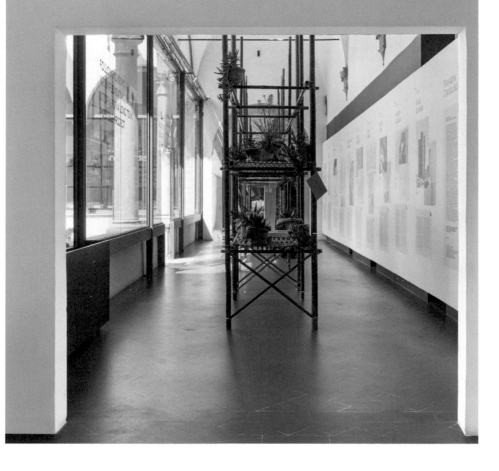

QUESTION OF GENDER

Luca Molinari

A few days ago Internet was inundated with dozens of images of the new Serpentine Gallery Pavilion in London, designed by Counterspace, a young collective from Johannesburg established by Sumayya Vally, a very talented female Muslim architect and the authentic intellectual soul of the group.

Contemplating a building with such a strong personality and unexpected formal characteristics, I was struck by the fact that Sumi (as she is called by her friends) was photographed inside the pavilion dressed in very elegant clothing designed by emerging stylists, almost like a declaration of the close relationship between the architectural structure and her physical form. In her visual research work and her teaching career at the University of Johannesburg, there is a subtle fixation combining female status, personal religious and cultural identity, and the substance of colour, with the study of the nature of the spaces we inhabit.

Observing this structure led me to reflect deeply on what the question of gender signifies in architecture and how difficult it is to try and get to the root of a question that is a blend of social, cultural and symbolic levels so different from one another, but that are well worth addressing with in-depth analysis and examples that can help us clarify the situation.

Personally, I firmly believe that talent has nothing to do with gender, but at the same time, I believe just as strongly that it is essential to grant everybody the same opportunities and possibilities of expression. This simple statement represents my pole-star in this short article and the reason why I believe it is fundamental to battle politically and culturally in order to abolish all forms of discrimination linked with gender, race, and social and religious origins. This should be our objective. There is no doubt that female architects belong to a category that has suffered the most discrimination and has been granted the fewest opportunities over the last century, with a gradual improvement that has been changing in recent times.

It is not enough to invoke names such as Gae Aulenti, Cini Boeri, Eileen Gray, Charlotte Perriand or the sadly missed Zaha Hadid, to confirm the role of women in a world that has been traditionally dominated by men, when women form the majority in architectural faculties and professional architectural firms, often as professionals of great quality. However, at the same time, I do not believe that the 'Indian Reservation' policy, with guaranteed lawful access for equal work opportunities, is enough to establish a good

practice that should be a normal part of our everyday lives as a matter of course. Instead, we must work on widespread education aimed at overcoming every form of discrimination, that considers the talent and personal capacity to make a contribution to our community as the only driving force to fight the challenges we face constantly in our daily existence.

At the same time, I look at the new generations, especially the younger ones, that are slowly emerging, and I have noticed that they consider the question of gender in an increasingly more complex, more fluid manner, overcoming the sexual bipolarism that has been widespread in the Western world for centuries. And this situation represents mankind's attempt to erase and move beyond the bijective division that has created the structure of our cities and the houses we live in: private/public, internal/external, natural/artificial, house/square, centre/suburbs, male/female. Perhaps the subject is different and cannot be interpreted simply as an advanced form of 'class war', but it should acknowledge a circular social and cultural condition, able to combine the human, natural and mineral with a view able to embrace the differences and to see them as amazing resources for changing the ecological conditions in which we live with ever-increasing difficulty. It means we must work on the key words that represent our lives and the environments in which we live to launch a genuine revolution that will overcome the questions of gender, and permit everybody to offer the contributions necessary to overthrow the deep crisis we are going through. This objective does not undermine the strength of the political and cultural battles that in this historic moment are rightly encouraging so many women to clearly and strongly declare the importance of reconsidering questions of gender in our society. However, I believe it is just as important to recognise a more radical wave of change that is sweeping our planet and could help us overcome certain contrasts concerning gender which have naturally arisen under the pressure of current generational and symbolic change.

All these subjects under discussion are strongly linked with architectural projects and new attitudes concerning urban structure that are undergoing debate and contemporary practice, because they could lead to increasing perception and different viewpoints in a profession which has become sterile and unable to portray a new era.

Following the painful pandemic, we are living in a society that should be trying to abandon the logics of aggressive and sterile performativity to embrace design aimed at listening, sharing, and transforming the world in which we live in a kind and radical way. This is why it is fundamental to reflect critically and politically on the questions being posed in the exhibition curated by Laura Andreini, to discover common and effective strategies that will enable us to finally leave the dregs of the last century behind us, identifying instruments and visions that are useful to benefit this world we share.

THE VOICE OF WOMEN, THE VOICE OF CONTEMPORARY ARCHITECTURE

Laura Andreini

The topic of gender inequality brings with it numerous controversies and possible objections: by classifying the female world into a category of its own, do we not run the risk of depleting its value? In light of gender equality, if it seems superfluous to dedicate an exhibition to men, then why dedicate one to women? The answer that the exhibition strives to provide to these possible objections is the conviction that an exhibition dedicated to the work of male architects would add nothing new to a narrative that has been going on for centuries.

At the moment, gender inequality does exist in our sector – as in all sectors – so it seems advisable to acknowledge it and seek the right strategies for putting it behind us. It would be wonderful if we did not have to compare male and female architects, but for the moment, this distinction exists and represents an irrational disparity. Let us talk figures. According to the latest Cresme survey (Centre for Economic and Social Research in the Building Market) conducted in 2015, there are 2.5 architects for every thousand in population. The European average is one architect per thousand, and women represent 42%. This signifies that for every thousand people, there are 1.05 architects, a percentage that could be defined as equivalent.

However, in actual practise, this is not the case. Women continue to remain in the background. Only a few tend to emerge and in the workplace they face more or less obvious barriers that prevent them from being recognised by the 'thousands' described above.

Discussing the role of women architects in contemporary society is a way to accord them the status and visibility they deserve.

How many books on women must we publish to normalise information that has ignored female action for centuries? In the light of these reflections, leafing though books and magazines published in recent decades we are aware of the lack of female narrative: a narrative that concerns both the authors and also the object of appraisal.

Initially, female architects were completely absent, while now they appear sporadically, but in a percentage that is far less than the 42% of the architectural graduates established in the Cresme report.

In the course of my personal experience, I have been able to ascertain that the difficulties faced by women are not identical in all the fields where architectural practise is involved.

On construction sites, a female architect's professional title disappears rapidly and many of the clients and those working on the project will call her 'Mrs'. In universities, this gender disparity seems fare less widespread. However, it should be noted that it has not yet disappeared, but the flood of female students who achieve excellent results have made it obvious to all that they represent a strong, deserving presence, and that, while they are still distant from the worksite, they do not feel a gender gap. At their age, I felt the same way.

It is worth noting that the debate on architecture designed by women has been growing more heated in recent years, and gender issues are generally being discussed more and more, first of all, because true equality is difficult to instil, not so much in the legal sphere as in the daily lives of every one of us; secondly, because we believe that we cannot omit a part of architecture that exists, that is of value and deserving of dignity. We are aware that the designs on exhibit have the capacity to inspire and we want the younger generations to become accustomed to the idea that architecture designed by women can also be a source of creative inspiration for them.

Another question regarded what form an in-depth exploration of this important issue should take. We thought that the best solution would be a debate, a round table, an open dialogue on the topic. On closer examination, you will notice that the points of view offered by the female architects are very nuanced.

The value of this exhibition lies in supporting female architects and giving them back a voice, bringing problems to light and demonstrating that the skills belong to individuals and are not merely professional baggage. Each architect interviewed freely expressed her point of view, offering insights for a general reflection on gender equality issues. I've often heard the question, 'Where are the women in architecture?'

Today, a small part is on exhibit, but the intention is to start writing about them and telling their unique stories.

We have to call attention to the systemic problems that persist in the sector and prevent women from rising in the ranks: still too few female architects are heads of studios or university faculties or managers of construction businesses, but by talking about it and lauding them, we create a crucial reference for those embarking on a career in architecture.

Our instructive contribution strives to amplify the voice of women in architecture, making them icons

in a profession in which they do a large part of the work, but that until now has pushed them to the side-lines. Mobilizing, raising awareness, building a healthy debate and supporting men and women from inside architecture. I don't believe that this is the only solution, but this is the direction that we have a duty to pursue.

For this reason, we wanted to put a question to an audience of female architects from different generational and geographic latitudes. We asked them to reflect on the condition of women in the field of architecture and any difficulties they may have come up against in the professional world. What emerged was a heterogenous picture, full of insights that demand our reflection. We wish to thank them all for willingly sharing their words and images with us.

WHAT IS YOUR OPINION OF THE CURRENT CONDITION OF WOMEN IN THE FIELD OF ARCHITECTURE?

HAVE YOU ENCOUNTERED DIFFICULTIES OVER THE COURSE OF YOUR CAREER OR DO YOU STILL COME UP AGAINST BARRIERS TODAY?

panels models

LAURA
ANDREINI

Even though great strides have been made over the last decades in terms of a female presence (the numbers of male graduates and female graduates in architecture are absolutely equal) and the dignity of professional women, the phenomenon of gender inequality is still evident.

During my career, I don't feel that I've ever been subjected to drastic inequalities. In fact, I've never thought of leaving my profession, but I have however consistently been aware of a sort of hazy filter that made the image of the professional woman disappear in the presence of men. Initially, to tackle this 'patriarchal system', I adopted typically male attitudes, adjusting my values to facilitate my working life.

Years later, I realized this was a mistake. Now I have a much better awareness of my identity, professionalism and skills, and this allows me to do my job with tranquillity, achieving results (in regard to gender differences) that at the beginning of my career would have seemed unattainable.

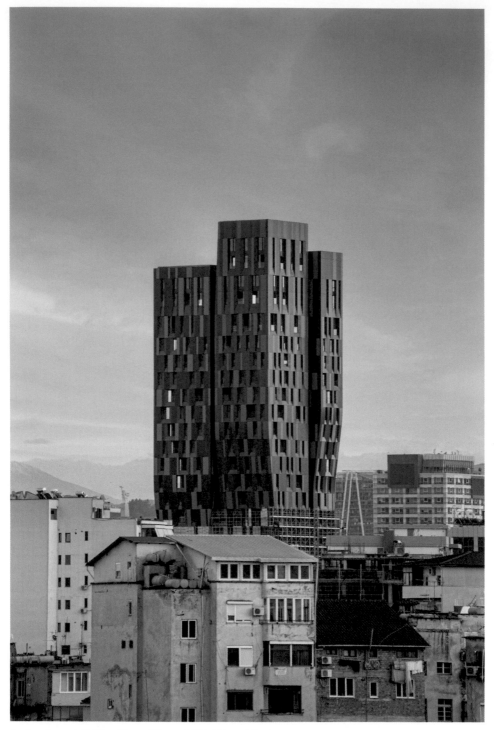

Archea Associati, *Alban Tower*, Tirana, 2021, ©Besart Cani

ARCHITECTURE DOES NOT HAVE A UNIQUE LANGUAGE: THE VOICE OF WOMAN COUNTS AND ENRICHES

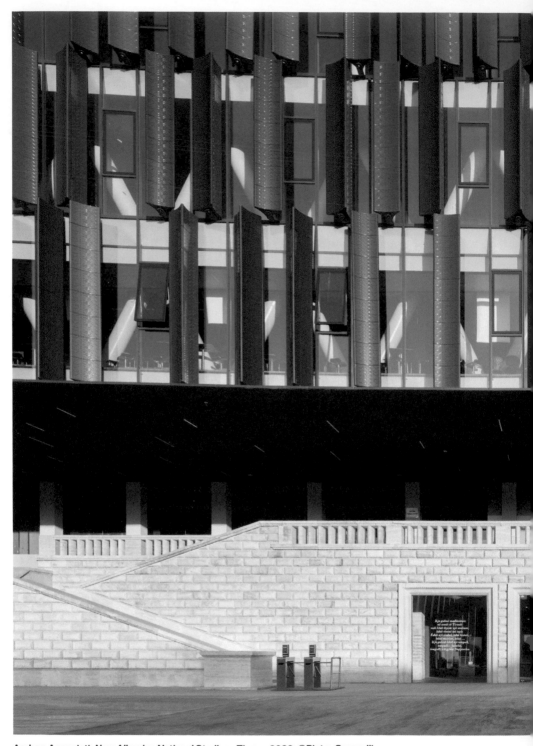

Archea Associati, *New Albanian National Stadium*, Tirana, 2020, ©Pietro Savorelli

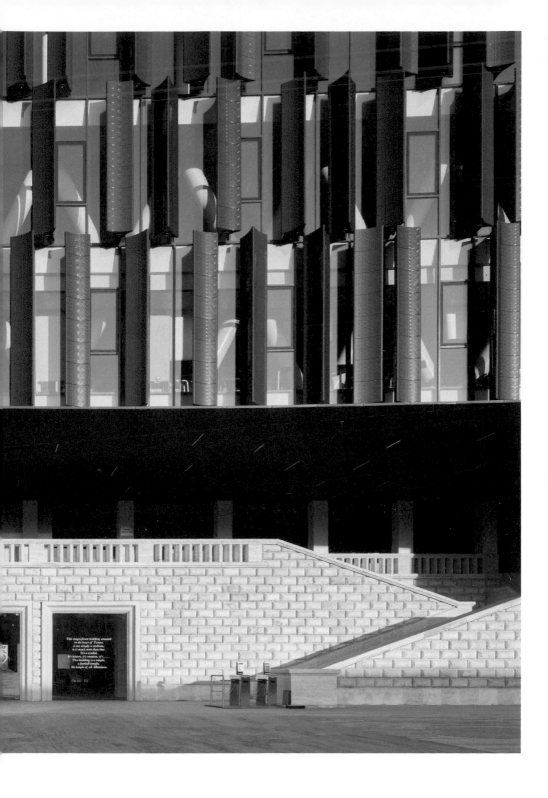

This magnificent building situated
in the heart of Tirana
is not simply a stadium,
it is much more than that.
It's a symbol,
it's history, it's emotion, it's......
This building is a temple,
a football temple,
the temple of all Albanians.

CARMEN ANDRIANI

I was born on December 5th in Rome in Prati di Castello (like Lina Bo Bardi) from two decidedly matriarchal families. I was educated in intellectual freedom, within the importance of culture and economic independence.

So I arrived in a well-equipped society (both professional and academic), but I often had to realize at my expense that the 'outside' was not so advanced. I believe in the merit of what we do rather than what we profess in words.

I have no prejudices and I have never believed in female quotas, a hypocritical palliative reserved for endangered species.

On the issue of gender, I naturally moved the bar a little further: the opposition is the last resistant datum of the rigid constructs of the twentieth century; on the contrary, we are moving towards gender fluidity, more appropriate to the postmodern culture of the third millennium, indefinite and without a centre, outside the stereotypes and opposing principles. To avoid doubt, however, my models are still two women: Margherita Hack and Patti Smith, risk and poetry. And the image that I bring you is that of an ongoing project: the restoration of the Bridge over the Basento in Potenza by the Roman engineer Sergio Musmeci. In confirmation of two taboos (we hope) that have been overcome: the infrastructure is (also) a work of architecture and a woman architect is (also) taking care of it.

FOLLOWING BEUYS' FOOTSTEPS, WE IMPLEMENT A CONCRETE UTOPIA FOR A LONG TERM POSSIBLE PROJECT

carmenandrianistudio, *Comunità Cantiere*, Staging at the Milan Triennial, Milan, 2015, ©Carmen Andriani

SANDY ATTIA

Women's voices are best amplified through other women. I believe in women empowering other women, and as such we should lead by example. Rather than limiting ourselves to demanding equal rights (from men) I would call on all women in decision making roles to seek out and hire women architects, not as a favor, not as an exception to the rule, not to fill a quota, but rather as a simple choice based on merit, in recognition of our capacities.

Women of all sectors play a role in elevating women's roles in architecture: (women) journalists must do the work and look past the headlines of our big name (male) colleagues and find the women buried in the story, they must seek out other voices; (women) public administrator officials must form networks of allegiances to women in our profession; (women) investors and entrepreneurs must believe that women can contribute equally with our perspective, acumen and competence. Each and every one of us must push back on the canons and mechanisms of the architectural discipline, of the building industry, and of the administrative cogwheels of architecture to affect positive change.

When I was at University, over half of my colleagues were women, in the studios that I teach, male students are a minority, where do all the women architects go, and why do we see less women in the architectural field? This is a question that all of us should ask ourselves.

RAY EAMES, ANNE TYNG, ALISON SMITHSON, DENISE SCOTT BROWN AND MANY... MANY OTHERS

MoDusArchitects, *Patricia Thaler's study*, Bressanone, 2018, ©MoDusArchitects

CRISTINA
CELESTINO

I think that the condition of women is still linked to a series of prejudices unfortunately rooted very deeply into our society.

These prejudices, or common ways of thinking, affect women daily and therefore, indirectly, also our profession.

Although women now occupy increasingly important professional roles and have fully demonstrated (if needed) their value in all fields, we often find ourselves diminished in our professionalism. For us who work in the creative sector, adjectives such as decorative, frivolous and cute are often used, as if the use of colour or soft geometries, as associated with the female designer, were immediately traced back to less 'serious', less institutional and less technical architecture or design.

Often being a woman designer is made into a debate by those involved in communication; on the other hand, I believe that design and architecture do not have genres, but unfortunately genres still exist as categories of clichés and gossip, these are frivolous and superficial.

Cristina Celestino/Attico Design, *Palazzo Avino*, Capsule collection for bedrooms and suites, Ravello, 2020, ©Davide Lovatti

Cristina Celestino/Attico Design, *28 Posti Bistrot*, Milan, 2020, ©Delfino Sisto Legnani, Agnese Bedini

THE WORK OF A DESIGNER IS THE SYNTHESIS OF A RESERCH THAT COMBINES, WITH THE FUNCTIONAL ASPECT, THE TENSION TOWARDS BEAUTY AS A VALUE, AN EMOTIONAL AND EVOCATIVE VISION AND A COMPONENT OF INNOVATION (FORMAL, USE, TECHNICAL)

IZASKUN CHINCHILLA

Inequity between men and women in the field of architecture is usually described with numbers and although they can be labelled as blunt and revealing, they are not able to effectively describe the causes and mechanisms by which the female lack of opportunities is generated. Karen Kingsley, evaluating Carol Gilligan's research argues that men and women have different approaches to understanding and structuring experience, different ways of organizing knowledge.

It suggests that the current way of organizing the curriculum in architecture schools, including workshops or design studios and juries, is homogeneous and uniform and excludes women and empowers males.

Kingsley argues that a deep reassessment of the curriculum is necessary for architecture training to promote real equal opportunities between men and women. Similar criticisms have been made to the incorporation into the professional world. In recent decades, women have been treated as 'immigrants' in the professional field of architecture.

At most, they were given the right to temporary stay in a 'land' that is not theirs, to learn the language, and to accept habits and rites.

At no time could they aspire to speak their own language or exercise their preferences in that place in which, generously but cautiously, they have been allowed to participate in the less skilled jobs.

Izaskun Chinchilla Architects, *Clementina coworking*, Barcelona, 2019, ©Imagen Subliminal

IN RECENT DECADES, WOMEN HAVE BEEN TREATED AS 'IMMIGRANTS' IN THE PROFESSIONAL FIELD OF ARCHITECTURE. AT MOST, THEY WERE GIVEN THE RIGHT TO TEMPORARY STAY IN A 'LAND' THAT IS NOT THEIRS, TO LEARN THE LANGUAGE, AND TO ACCEPT HABITS AND RITES

MARIA CLAUDIA CLEMENTE

In reality, architecture is made up of many aspects and multiple paths of development, it is difficult to generalize: there are aspects related to design, the relationship with the client, the time limits of the construction site, studio management, communication, etc.

Each phase has its own specificity also in human relationships, because it is in human relationships that respect and recognition are measured. In this regard, I must say that paradoxically the most masculine moment of all, the construction site, is the simplest one: the workers listen to the indications given to them to build, no matter by whom or how they are given; they understand if those in front of them can help them solve their problems.

Respect only comes from there: from skills.

Contrarily, it is a little different in the initial stages, where the central figure is the client and therefore respect and dialogue are built on the basis of culture; in this case it might not always be easy to overcome initial distrust, especially if we are not willing to sacrifice our own specificities.

Yes, because I think that there are specificities between men and women linked to method, language and the view of the world; obviously not to the merit or intellectual or creative aspects.

These are related to the individual, who knows no gender.

This is why we still have to fight a little!

ARCHITECTURE IS A COMMON GOOD. IT SHAPES OUR TERRITORY, IN WHICH THE LIFE OF ALL CITIZENS TAKES PLACE, DEFINES OUR SOCIAL AND CULTURAL HORIZON

Labics, *Visionair*, installation, Milan, 2018, ©Maria Claudia Clemente / Labics

ISOTTA CORTESI

The architect's job is wonderful! I have been accompanied to architecture by the hand since childhood and I have gathered the knowledge of construction, as a legacy, from the two generations that preceded me.

They were obviously men. This prepared me for confrontation, prejudice and the fact that Italian men, even at work, tend to consolidate an exclusive, closed and supportive relationship with one other as if they were in the changing rooms before a soccer match.

So I undoubtedly developed a greater tenacity and I had to acquire different skills to overcome the diffidence imposed by the prejudices which were widespread among the workers and even more so among colleagues dedicated to construction. I learned the trade from men, both in the studio and on construction sites. Indisputable, however, is our superior ability, as women architects, in coordinating, managing and solving complex situations while we are also able to pity, with a sarcastic smile, those who still today, on site, look at you, in the full maturity of my work, and say 'but who on earth told you to come here instead of staying at home'. Such firmness I learned from my mother, a feminist lawyer, a public figure who fought for autonomy and the differences in being a woman in life and in work.

Cortesi Architetti, *Cela housing in hillside landscape*, Parma, 2020, ©Cortesi Architetti

REVOLUTION IS GENERATING BEAUTY IN SPACE, IN FORMS AND CULTURE WITH THE BIOCENTRIC INTENSITY

Cortesi Architetti, *Piazzale Fedro*, Parma, 2004, ©Cortesi Architetti

ELIZABETH DILLER

Architecture has been male-dominated forever and I am a grateful beneficiary of the women's movement. My studio's success is a sign of a dramatic change in the profile of what an architect looks like. No longer are we seeing the singular heroic voice – that genius person that gets a lightning bolt from God. Instead we're seeing collaborations of different sorts, like the collective of my own partners at Diller Scofidio + Renfro.

As a practitioner, I must say I haven't been subjected to negative discrimination. I've been able to construct a firm of my own and we've been able to do progressive work.

Saying that, I'm also struck by what I see as an educator and professor at Princeton. Fifty percent of my students are female and somehow only twenty percent make it to the workplace. This is something that is difficult to decode. How does this happen?

Where is the attrition?

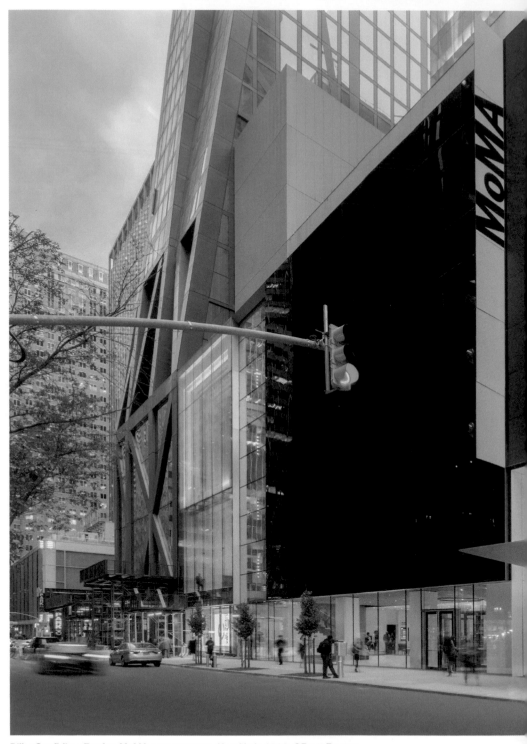

Diller Scofidio + Renfro, *MoMA*, new entrance, New York, 2020, ©Brett Breyer

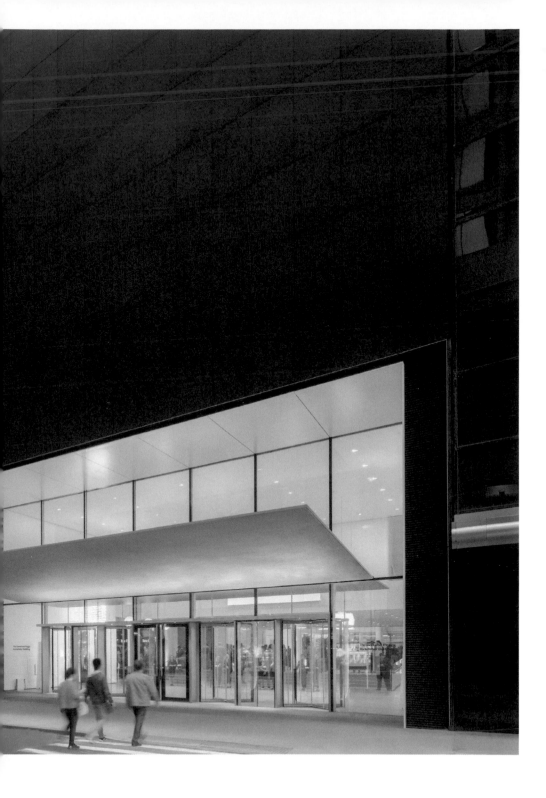

↗ Terrace Café

Diller Scofidio + Renfro, *MoMA*, internal views of the museum, New York, 2020, ©Iwan Baan

ARCHITECTURE HAS BEEN MALE-DOMINATED FOREVER AND I AM A GRATEFUL BENEFICIARY OF THE WOMEN'S MOVEMENT

LINA
GHOTMEH

Diversity is essential to our environment, to us as humans. It is undeniable that our habitats, our cities, have been built with a male gaze, in an anthropocenic construct that lacks enough inclusion whether to 'minorities', to nature or more specifically to women.

I see it both as essential and urgent to the wellbeing of man and that of woman, of gender in general, to the balance our 'milieu', to ensure spaces of negotiations, ones where dialogue and difference could happen and where an alternative way of inhabiting could be possible.

It requires knowledge, time, resilience, and observation to highlight these processes of marginalization. It also requires courage and perseverance to voice out discrimination.

As an architect who started my career with two male partners, I have been able to sense very closely clear sentiments of unease and unacceptance towards me if I am proven to be a good architect or when I am to voice out what I would have designed. In this specific case, it would be accepted and looked up to when a male claims his designs and contribution to architecture. However, in the exact same situation, it would be considered too loud, malefic, uncollaborative, sometimes doubtfully unethical for a woman to express her being through what she has meticulously drawn and put very carefully to life if that design happens to be without any creative input from anyone but her.

These — what Pierre Bourdieu would call 'habitus' — are embedded structures of thoughts, of being, that may not be expressed 'on purpose'. They are part of the educational system but they still need to be pinpointed and driven to change to stop pulling 'Her' down.

Lina Ghotmeh – Architecture, *Mina Image Centre*, Beirut, 2016, ©Iwan Baan

ISN'T IT TIME TO HAVE A MORE DESIRABLE WORLD FOR ALL?

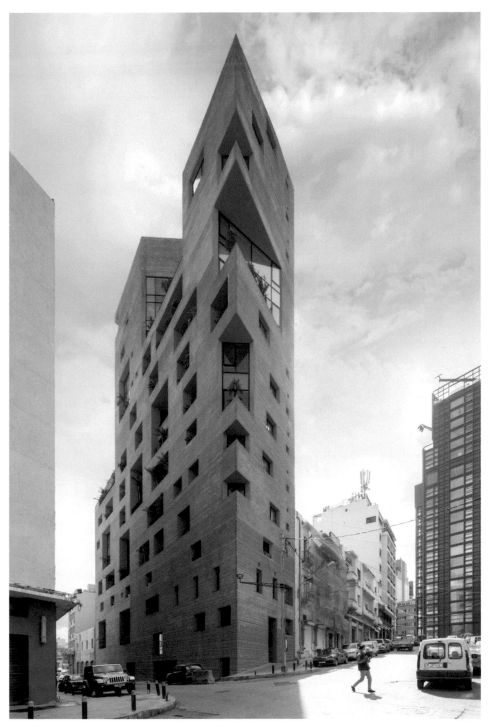

Lina Ghotmeh — Architecture, *Stone Garden*, Beirut, 2016, ©Iwan Baan

CARLA JUAÇABA

Women always have to face difficulties, even in more civilised contexts. These difficulties are veiled, so they become more difficult to see.

Of course, the problem is not only in our profession but in many others. In fact, I think that female discrimination begins at home, in the family context. So the fight for equality begins there, in most cases. You have to go through that since you were a little girl, and that is the hardest part.

I grew up in a house with two brothers, and I see a tremendous difference in treatment. What they think has more value, what they do has more value (although this is entirely unconscious in my opinion).

It needs a strong emotional structure to face this without ruptures and stress.

Female discrimination at home is a simulacrum of the world. From there to the world.

I would go to a march in favour of Malala Yousafzai, because there is a real cause, but I would not go to a march for the feminist movement itself.

Carla Juaçaba Studio, *Vatican Chapel*, overhead view of the Chapel in the San Giorgio Maggiore island gardens, 2018, Venice, ©Federico Cairoli

FEMALE DISCRIMINATION AT HOME IS A SIMULACRUM OF THE WORLD. FROM THERE TO THE WORLD

FUENSANTA NIETO

Architecture has no gender, there is no feminine and masculine architecture.

The important question is the way in which each architect – woman or man – designs and interprets the world around us, the city, the landscape, the places we inhabit, which implies great social responsibility. Architecture can be practiced from different fields: design, planning, construction, teaching. Although there may be now a majority of female students in most architecture schools – which was not the case when I was studying – at the teaching level, the percentage of female professors is still lower, and in professional practice the number of women is even smaller. On the other hand, the economic and strategic decisions that so much influence the construction process are dominated by men, with the consequent difficulty for female architects.

Throughout my career I have seen positive changes and I consider myself very fortunate to be able to practice architecture designing, building and teaching, as well as having a family and children. But what in my case can be seen as the result of both effort and luck, that should be normal for every woman who proposes it. That is why I believe it is essential to continue supporting, promoting and helping women to be much more present in general in all professional fields and particularly in architecture.

ARCHITECTURE HAS NO GENDER: THERE IS NO FEMININE AND MASCULINE ARCHITECTURE

Nieto Sobejano Arquitectos, *Arvo Pärt Centre*, Laulasmana, Estonia, 2018, ©Roland Halbe

Nieto Sobejano Arquitectos, *Arvo Pärt Centre*, Laulasmana, Estonia, 2018, ©Roland Halbe

SIMONA
OTTIERI

I don't like to think of women as a category because I don't like to think by categories, but the problem of the condition of women exists and despite the progress made so far, it is important not to stop and use every possible opportunity to gain a position.

I remember an engineer who called me 'Miss'. Architect, woman and even young, the worst of the worst. Deep down I thought 'poor thing!' and I carried on. Even today, and I admit I'm no longer young, I meet some poor creatures.

Of course it is sad and it is also hard to live with, but it is a cultural problem that goes beyond the profession.

Paradoxically, apart from a few moments of anger, the difficulties encountered in this area remain the ones that scare me less.

Sometimes it's a tug of war. But when the weapons to be used are not physical, it is not about fighting to defend onself but to win. And when it happens, and it happens often, the satisfaction is immense.

And that is why I love signing myself:
Simona Ottieri. Architect.

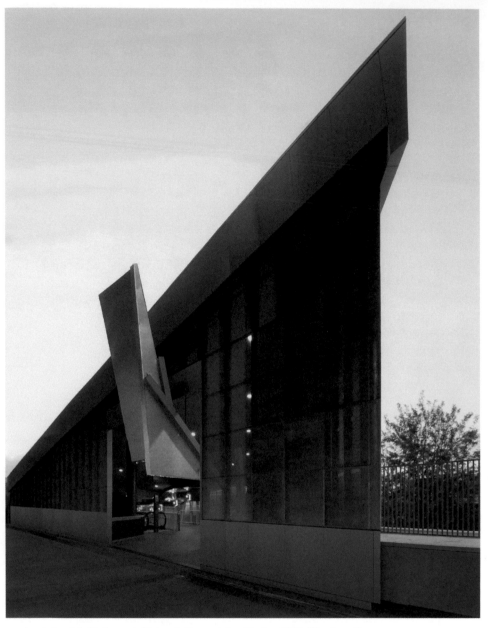

gambardellarchitetti, *Scampia Metro station restyling*, Naples, 2019, ©Luciano Romano

A CULTURAL REVOLUTION BASED ON EQUAL COMPETITIVE CONDITIONS AND DIVERSITY AS A VALUE IS NEEDED

CARME
PIGEM

The practice's team is 70% women and we have continually supported the presence of women in our projects. In addition, at least half of the participants of the studio's annual RCR Summer Workshops have been women. This is in line with the growing number of women who choose the architectural career.

Of course, there is still a lot to do, especially in matters of the profession and motherhood.

I have been fortunate to be able to work as an architect and be a mother. This has been possible because my partners have supported it as something natural and that is why I now represent the first woman with a Pritzker prize who has also had the opportunity to be a mother.

I consider and hope that future generations of women will not allow to disappear behind the shadow of their partners. An option to achieve that balance may be to think in terms of sharing authorship and the creative process, as we have done under the concept of 'shared creativity'.

WOMEN'S VISIBILITY MAY RISE UNDER THE CONCEPT OF SHARED CREATIVITY BY SHARING THEIR AUTORSHIP AND CREATIVE PROCESS

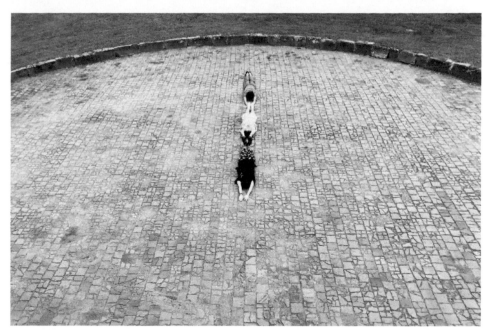

RCR Arquitectes, *Summer Workshop*, La Vila, 2018, ©Carme Pigem

GUENDALINA SALIMEI

It's not easy to answer this question, because on the face of it, there are no specific biases, or better still, what we feel is often something so subtle that it is hard to deconstruct.

There are women in the working world but rarely do they play leading, strategic, or managerial roles, often relegated to working on the side-lines. No one really knows why it continues to be this way, but even in the civilized western world, there is very strong resistance to considering women as equals, and this in the world of architecture as well, a world that has always been considered male. But I'm convinced that in today's society, it is crucial that there be multiple points of view and sensibilities.

Women's ability to see things and facts from both transversal and 'secondary' perspectives means that we are better able to grasp the unseen, the hidden, that which lies behind, and it makes us better at interpreting the changes underway.

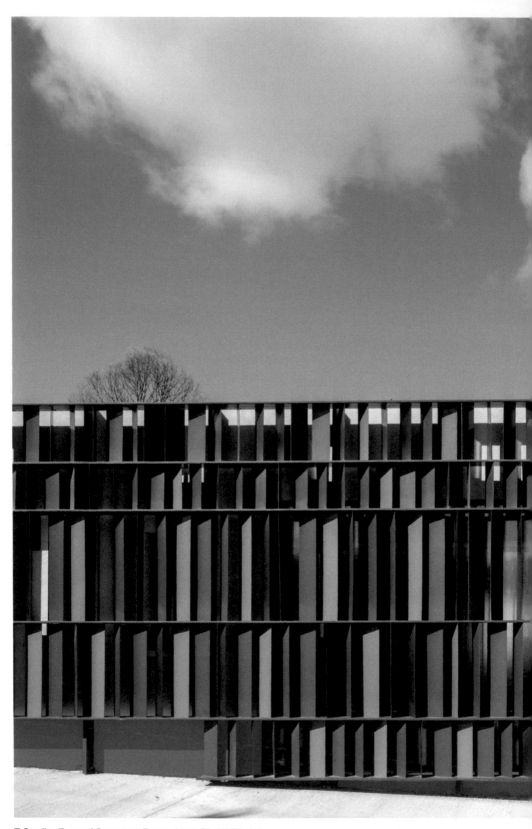

T-Studio, *Frascati Cemetary*, Rome, 2017, ©Luigi Filetici

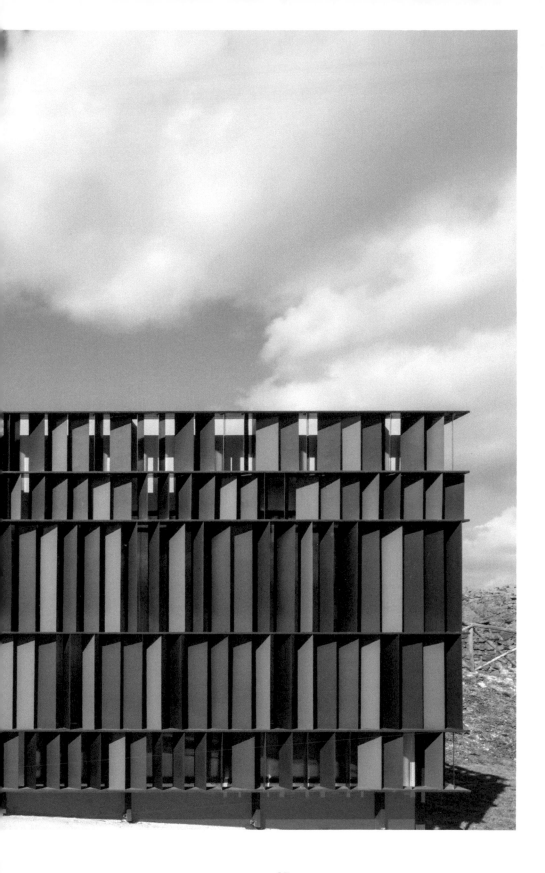

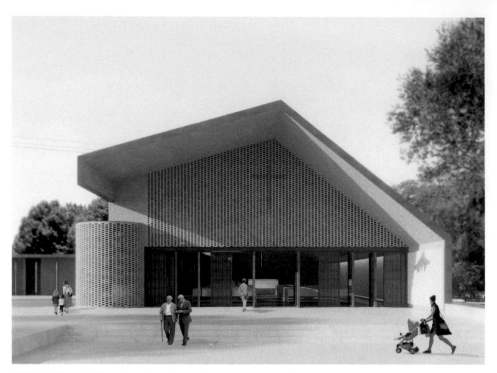

T-Studio, *Cannavà Church*, project design for a church, Reggio Calabria, 2019, ©T-studio

PROGRESS IS IMPOSSIBLE WITHOUT CHANGE AND THERE CAN BE NO REAL CHANGE WITHOUT WOMEN!

MARELLA
SANTANGELO

There is a female specificity in creating architecture, a woman's point of view in seeing the things of the world and imagining their transformations. Ours is a wonderful job that can change the world, but the world is still often unable to accept that women can be the architects of this change.

When women are allowed to work in architecture, the differences emerge powerfully as well as the ability to control all processes, without exception. The very high level of the architecture designed and built by women tells us that we are, however, doing well.

With the stubbornness that characterizes us, we move forward dodging the many obstacles that still exist and that lead us today to reflect together on the future of women in architecture, those same obstacles that make us struggle in the daily aspects of our working lives, whether professional, academic or personal.

Interlocution with and among the top management continues to be mostly with men, who find it difficult to compete with women who have power; but as always it is a cultural fact and architectural culture can be a powerful weapon to break down those obstacles and project us increasingly further forward.

Marella Santangelo, *Casa SDM Napoli, Naples seen through space*,
2019, ©Marella Santangelo, Paolo Giardiello

ARCHITECTURE IS MAINLY IN ITS CIVIL AND SOCIAL DIMENSION

MARIA ALESSANDRA SEGANTINI

For me, architecture is an opportunity to capture the DNA of the place, its light, the material, the climate, the desires of the people who live there, to design a hybrid that maintains the continuity, and becomes the interpreter of that place. The beauty and form transmit the roots of that place. They transmit the synthesis and response to the climate, the topography, the circular consumption of the available natural resources, and the time and desires of the people who live there.

For millennia, women have been taking a holistic approach to passing on values from one generation to another. They care for them and strive to bring out the potential that they glimpse in their children.

Looking at a design for a site in the same way, they will work to restore continuity with its roots. They will cultivate and strive to bring out its potential, look after its well-being and stability with the same sensitivity with which they would stroke the cheek of a child.

C+S Architects, *WFP. Water Filtration Plant*, Sant'Erasmo island, Venice, 2008, ©Pietro Savorelli

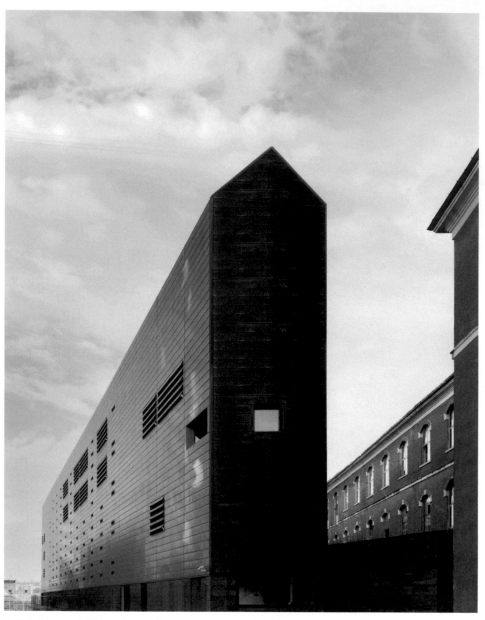

C+S Architects, *LCV. Law Court Offices*, Venice, 2012, ©Pietro Savorelli

I DESIGN TO EXPAND THE POTENTIALS OF PLACES, SO WHAT IS POSSIBLE FOR A FEW, CAN BE EXTENDED TO MANY

BENEDETTA
TAGLIABUE

How strange that we women have always occupied
a silent, undescribed place in history...

Perhaps it's because, in every corner of the world,
we've been the creative beings par excellence?

Perhaps it's because we've always been the
cornerstone of society?

Sometimes I think that just by remembering,
we'll know that history is made up of women, that
society has always depended on women, described
and undescribed, and that with this awareness, today
we can even be so bold as to tell our stories, become
visible, accept leadership roles, change 'history'...
even the history of architecture!

*IT IS STRANGE THAT
THROUGHOUT HISTORY
WE WOMEN HAVE
ALWAYS OCCUPIED
A SILENT SPACE, NEVER
DESCRIBED...*

*PERHAPS BECAUSE
WE HAVE ALWAYS
BEEN THE CREATIVE
BEING PAR EXCELLENCE
IN EVERY CORNER
OF THE WORLD?*

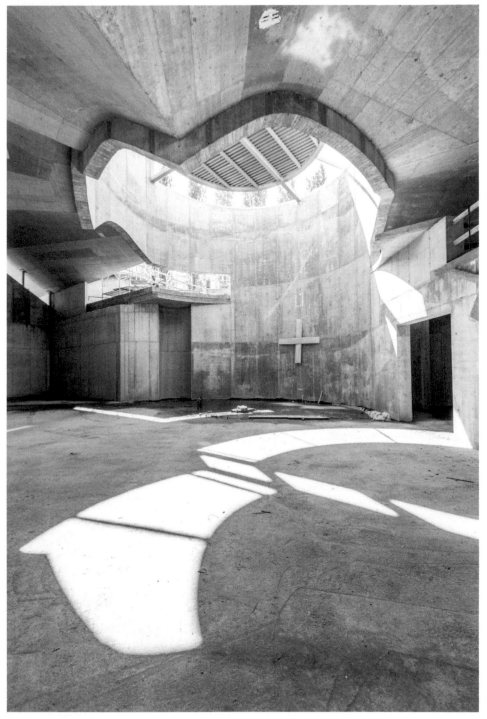

Miralles Tagliabue EMBT, *Church of San Giacomo*, Ferrara, Italy, 2021, ©Paolo Fassoli

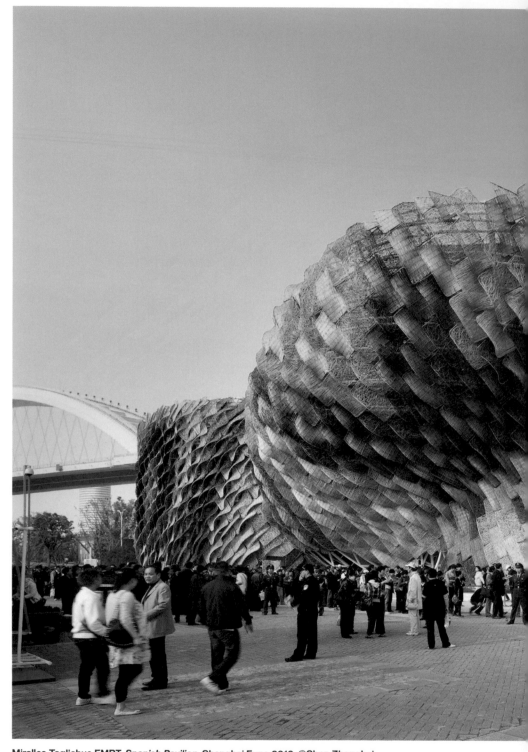

Miralles Tagliabue EMBT, *Spanish Pavilion*, Shanghai Expo 2010, ©Shen Zhonghai

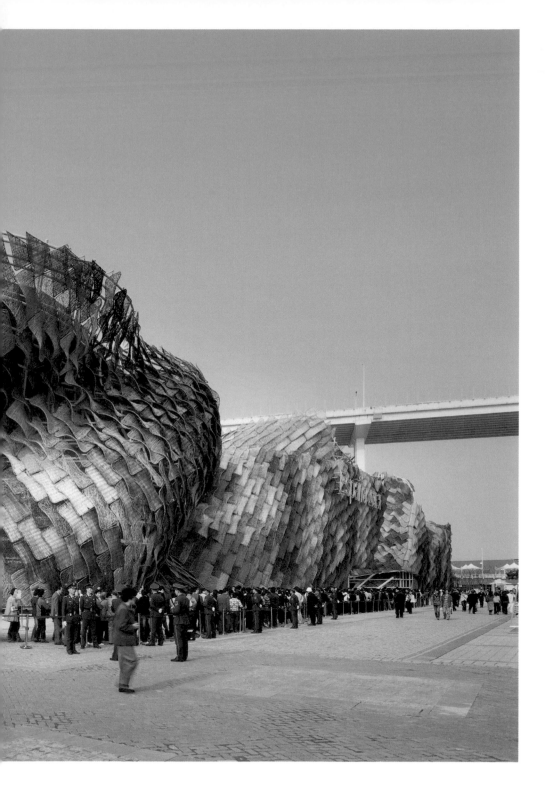

MONICA
TRICARIO

As Gae Aulenti said, 'architecture is a man's job, but I have always ignored it'.

I don't think gender affects the design process, it is more connected to the facets of an individual, such as creativity, skill and experience.

We at Piuarch have always appreciated the team and its cohesion. This aspect has profoundly shaped our design process which reflects our plurality.

This idea of unity could be an interpretation to go beyond the concept of gender equality in the workplace.

Women have a natural predisposition to harmonize and smooth out situations and critical issues. I think my natural role has always been to balance personalities, maintain cohesion and find the perfect synergy between different temperaments. But in general this is often not enough, it is also necessary to put into play an infinite series of strategic skills that allow you to reconcile working life with everything that is outside it, which for millenary cultural heritage is the prerogative of women.

In no way is the company structured to favour and support women's work. As long as men do not deal equally with everything other than work, I believe we will never arrive at a fair distribution of opportunities. And I think that day is still a long way off.

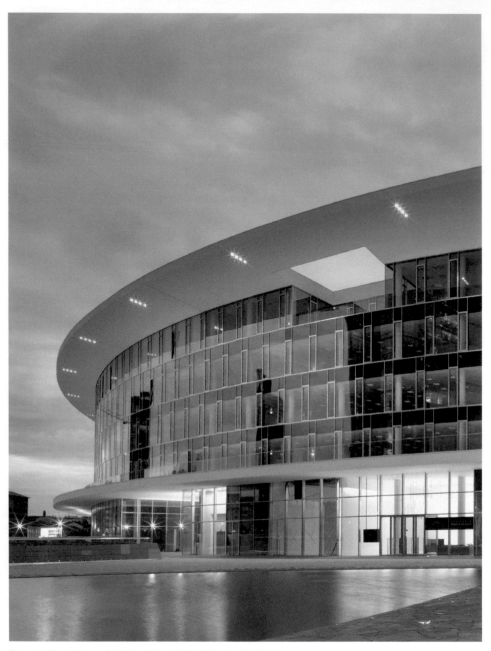

Piuarch, *Porta Nuova Building*, Milan, 2019, ©Andrea Martiradonna

WORKING AS A COLLECTIVE, ANIMATED AND SUPPORTED BY A SHARED GOAL, IS THE BASIS FOR OVERCOMING THE GENDER GAP

PATRICIA
VIEL

The condition of women is no different in architecture from that in politics, medicine, civil aviation or art.

For the most part, the handicap is still unbridgeable and comes from the sense of responsibility that women have towards their family, the desire or ambition to have children and the difficulty especially in this country, to do so by pursuing a commitment of excellence in one's work.

The political and social context must support the family as a resource, a good and collective responsibility towards the future and must do so by supporting women through the care of children from an early age, but not only that. Much is being done to involve everyone in this responsibility but not enough on the front of the effective recognition of the value of this aspect in the growth of a country.

The pandemic opens up new perspectives of freedom especially in these outdated rituals and generates new options for collaboration and exchanges of roles in the family thanks to a revived relationship with work and with time in daily life.

It is a technical aspect in some respects even before it is cultural, in reality women emerge when they are free to fully engage in their own activity and this depends on constant commitment, the ability to collaborate and the refusal to be or appear what they are expected to be.

We should observe the decline of the baby boomers generation, of which I am part, of our rituals and social models to see real equality of gender and opportunity appear, but I believe that for us Europeans, this is a priority goal. Unlike other regions of the planet, we have the capabilities, the possibilities and the opportunities to reach it and consolidate it in a model of social and cultural growth, before economic, which sees its indicators of improvement in well-being and in the quality of social coexistence as a condition and in equity and equal opportunities as a goal.

WE WILL HAVE TO SEE THE DECLINE OF OUR SOCIAL RITUALS AND MODELS TO SEE REAL EQUALITY OF GENDER AND OPPORTUNITY APPEAR

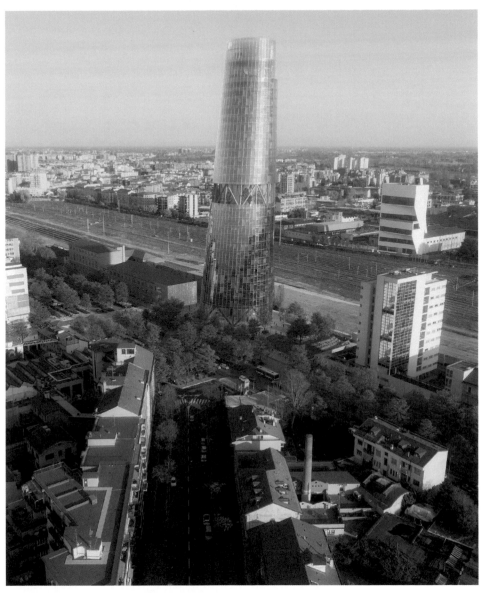

Antonio Citterio Patricia Viel, *A2A Faro Tower*, rendered project design,
Milan, ongoing, ©Antonio Citterio Patricia Viel

PAOLA VIGANÒ

If we start with the facts, for example, the percentage of women studying architecture, or the percentage of female professors of architecture and urban planning, the answer to your question can only be depressing. Even though there seems to be a change in the perception of an active female presence in the world of design, and even though some female figures have assimilated architecture's traditionally male image, in structural terms, this condition is still marginal.

Reflecting on this makes me think back to the strides made by the women's liberation movement during my adolescent years, when I believed that the problem of the woman's role and position in 'modern' society had been solved once and for all. Consequently, I've always avoided gender-based confrontations. They seemed antiquated to me and corresponded neither to our society nor to my vision of the world. Certainly, there have been some startling moments when this confrontation – clash struck me as being somewhat violent.

But speaking more generally, I was mistaken in thinking that the gender issue had vanished: today it has exploded all over again with such force, and directly involves our female students, architects and young researchers. We are forced to face it once again. Personally, I think the time has come to get past it: to go beyond gender.

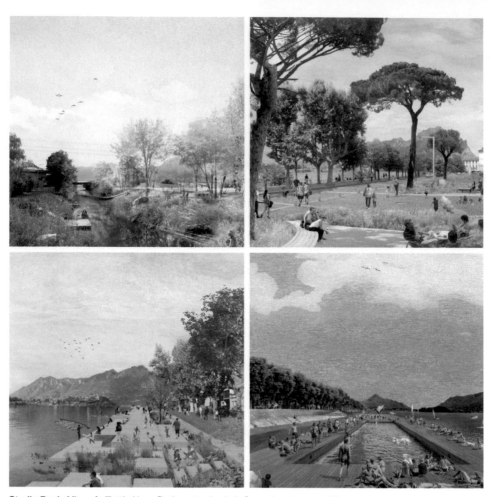

Studio Paola Viganò, *Tutti al lago* [let's go to the Lake], rendered competition design,
Lecco, 2020, ©Paola Viganò

THE GENDER ISSUE HAS NOW RE-EXPLODED WITH GREAT FORCE. WE ARE FORCED TO FOCUS IT AGAIN, TAKING IT BEYOND: THE TIME HAS COME TO GO FURTHER. BEYOND THE GENDER

APPENDIX

LAURA ANDREINI

Laura Andreini is co-founder of the studio Archea and is Associate Professor of Architectural and Urban Composition at the Faculty of Architecture at Florence University where she graduated with an honours degree in 1990 and was awarded her PhD in 1997. In 1988, with Marco Casamonti and Giovanni Polazzi she founded Archea in Florence. Since then, alongside her architectural and teaching career, she has focussed strongly on research and critical analysis in the fields of architectonics, architectural and industrial design in collaboration with some of the leading manufacturers of architectural components using professional environments to field test her theories in the domain of contemporary architecture. For 6 years she worked as a journalist at *Area. Rivista internazionale di architettura e arti del progetto*, currently published by Tecniche Nuove publishers in Milan, where she was appointed deputy editor in 2003. In April 2018, she began collaboration with the Museo Novecento in Florence where she was entrusted with the curation of a series of exhibitions and conferences entitled *Paradigma. il tavolo dell'architetto*. This exposition features famous architects, architectural collectives and firms in contemporary Italian and international architecture.

CARMEN ANDRIANI

Carmen Andriani is a Full Professor and architect specialised in concentrated urban contexts and other environments with particular focus on abandoned industrial buildings, transformation of dockland areas, relationships between infrastructures and the landscape, procedures for the regeneration of fragile territories in the Adriatic and more widely, in the Mediterranean. Her research projects are concentrated on the transformation of coastal landscapes, urban waterfronts and infrastructural, dockland, ex-industrial or abandoned areas along coastlines. Special focus is placed on the intermediate areas located between cities and ports that are subject to constant modifications as a result of industrial sites in disuse, obsolescent open spaces and infrastructures, and overall states of dereliction despite the importance of certain structural complexes.

SANDY ATTIA

Sandy Attia founded the architectural firm MoDusArchitects with Matteo Scagnol in 2000. The practice is widely recognised for its heterogeneous approach to architecture based on the different cultural and educational backgrounds of the two founding partners, which they have combined to form a daring platform of architectural design. Their completed projects include infrastructures, buildings, and bespoke interior design for public, civic and private commissions. MoDusArchitects has won numerous awards including an Honourable Mention in the Italian Architecture Gold Medal Awards in 2015 and 2012, first prize in the Oderzo awards in 2014, first prize in the Piranesi Prix de Rome in 2014, and the special prize by the jury in the Italian Architect of the Year competition in 2013. The same year, the firm was invited to present a project for the *Energia* exhibition at the MAXXI in Rome, and in 2015 it was one of the ten practices selected by the Ministry of Cultural Heritage to submit a project for the curation of the Italian Pavilion at the 2016 Biennale di Venezia.

CRISTINA CELESTINO

After graduating from the School of Architecture at IUAV University of Venice in 2005, Cristina Celestino worked with prestigious design studios, focusing on interior architecture and design. In 2009 she moved to Milan, founding two years later her brand Attico Design. In 2013 she opened her own design studio. In occasion of DesignMiami/ 2016 Cristina designed *The Happy Room* collection for Fendi. As a designer and architect, Cristina Celestino creates exclusive projects for private clients and companies. Her work also extends to creative

direction for companies, and the design of interiors and displays. Cristina has received many international prizes and honours, including the Special Jury Prize in the Salone del Mobile Milano Awards in 2016 and the Elle Deco International Design Award in the Wallcovering category in 2017 with the wall covering project *Plumage* for Botteganove and in 2019 with the wall covering collection *Giardino delle Delizie* for Fornace Brioni.

IZASKUN CHINCHILLA

Izaskun Chinchilla studied at Escuela Técnica Superior de Arquitectura in Madrid from where she graduated with honours in 2001. At the moment, she is in the process of completing her doctoral thesis, entitled *Sustainability and Architecture: Revolution, Crisis or Orthodoxy?*, in the same institution. She is also a Senior Teaching Fellow and Researcher at the Bartlett School of Architecture, UCL. Since 2001, Chinchilla has also been the driving force of her own practice.
Its work has been exhibited extensively and has shown in the Biennale di Venezia on several occasions. Apart from several installations and small to medium range refurbishments, the practice also works on housing and museography projects along with urban planning commissions. Its largest undertaking to date is the refurbishment of the Garcimuñoz Castle in Cuenca, Spain. Demonstrating a thorough understanding of the historic context, this project manages to find the balance between a desire for new infrastructure and the need to preserve the existing built environment.

MARIA CLAUDIA CLEMENTE

Alongside her teaching and research career, Maria Claudia Clemente has always been strongly involved in architectural design. The Labics firm, that she established in 2002 with Francesco Isidori, was selected in 2004 by *Architectural Record* as one of the ten most promising international architectural practices. Since its beginnings, Labics has won several competitions including a competition by invitation launched by G.D. for a multifunctional building in Bologna in 2006, and another in 2007, launched by the Rome City Council and Atac for an urban restoration project in Rome. Both projects are currently underway. As well as its urban architecture, since its foundation Labics has also focussed on interior design, not only for private commissions, but also for the Obikà restaurant chain in numerous cities both in Italy and abroad. It also creates public design projects such as the new layout, functional design and signage for the Traiano Markets, and the new project for piazza Fontana at Rozzano (Milan). In 2010, with Massimo d'Alessandro and Susanna Mirza, Maria Claudia Clemente edited two monographs on public spaces in contemporary cities for the industrial design review, *diid*. Works by Labics have been exhibited at the XI and XII editions of the Biennale di Architettura di Venezia.

ISOTTA CORTESI

Isotta Cortesi is an architect and landscape designer, and teaches at Federico II University in Naples. Her professional work is mainly centred on project design applied to different scales, with special focus on experimenting with the dimensions of landscape in relation to architectural design, down to detail survey. In particular, her architectural research is focussed on using each project to explore ways to transform contemporary urban areas and landscapes, and to observe and understand the changes in inhabited spaces. She has designed building in Italy, several of which have been featured in leading architectural publications. She has participated in architectural competitions, winning recognition and several awards. Her main focus has always been centred on the concept of open space in contemporary cities, with an independent vision on the design of urban spaces. She has written articles for numerous publications, books and reviews. Isotta Cortesi teaches courses, and holds conferences and seminars in

international universities in Italy and abroad. She is a Fulbright Fellow of the American Academy in Rome.

ELIZABETH DILLER

Elizabeth Diller is a founding partner of Diller Scofidio + Renfro (DS+R), a design studio whose practice spans the fields of architecture, urban design, installation art, multi-media performance, digital media, and print. Diller and co-founding partner, Ricardo Scofidio have been distinguished with *Time* magazine's 100 Most Influential People list and the first MacArthur Foundation fellowship awarded in the field of architecture, which stated: 'Diller + Scofidio have created an alternative form of architectural practice that unites design, performance, and electronic media with cultural and architectural theory and criticism. Their work explores how space functions in our culture and illustrates that architecture, when understood as the physical manifestation of social relationships, is everywhere, not just in buildings.' The studio was recently awarded the Wall Street Journal Magazine's 2017 Architecture Innovator of the Year Award and is the recipient of the Smithsonian Institution's National Design Award, the American Academy in Rome Centennial Medal, and Fast Company's Most Innovative Companies Award.

LINA GHOTMEH

Born in Beirut, Lina Ghotmeh grew up in this ancient cosmopolitan city marked by the scars of the Lebanese civil war. Although she wanted to become an archaeologist, Lina carried out her architectural studies at the American University of Beirut, where she looked at the notions of memory, space and landscape through her own methodology entitled 'Archeology of the future'. After graduating and being awarded both the AZAR and AREEN prizes. Lina pursues her education at the École Spéciale d'Architecture in Paris where she takes on a teaching role as an Associate Professor between

2008 and 2015. In 2005, while working in London and collaborating with Ateliers Jean Nouvel and Foster & Partners, she wins the international competition for the design of the National Estonian Museum. After this victory, she co-founded her first agency DGT Architects in Paris and lead the realization of the large scale project of the National Museum. Acclaimed unanimously by the international press and having won prestigious awards (Grand prix AFEX 2016; nominated for the Mies van der Rohe Award 2017), the museum became the symbol for an avant-guardist architecture, combining pertinence and subtlety. Thanks to her multicultural experiences but also her engagement in the challenges of our time, she is regularly invited to speak at conferences, take part in juries and workshops in France and abroad.

CARLA JUAÇABA

Since 2000, Carla Juaçaba developed her independent practice of architecture and research based in Rio de Janeiro, Brazil. Her office is currently engaged in both public and private projects, focusing on housing and cultural programs. Since undergraduate student she worked with the architect Gisela Magalhães of the Niemeyer's generation, mostly in the area of exhibitions related to the Brazilian native arts and historical museums. During her first year after college (2000) she worked jointly with another architect Mario Fraga on the project named *Atelier House*. Following that, a series of projects have been conceived such as the *Rio Bonito house* (2005), the *Varanda House* (2007), the *Minimum House* (2008), *Santa Teresa House* in its final stage (2012), and a couple of exhibition design. Current works includes the ephemeral pavilion conceived with the senior scenographer and theather director Bia Lessa, *Humanidade2012* for Rio+20, the recent international meeting held in Rio de Janeiro. And also tow houses on the outskirt of Rio.

Carla Juaçaba is constantly a part of the academic and teaching realms, as well as research studies, lectures, biennales, exhibitions and was the Jury at BIAU Bienal Ibero Americana in Madrid (2012). She is currently teaching at FAU-PUC RJ Pontifícia Universidade Católica. Her work is focused on an intrinsic issue of the discipline: the poetics of tectonics, and its expressive potentiality.

FUENSANTA NIETO

Fuensanta Nieto has worked as an architect since graduating from the Universidad Politécnica de Madrid and the Graduate School of Architecture and Planning at Columbia University in New York in 1983. She is a founding partner of Nieto Sobejano Arquitectos and a professor at the Universidad Europea de Madrid.

Fuensanta Nieto lectures on architecture and participates in juries and symposia at various institutions around the world.

From 1986 to 1991 she was co-director of the architectural journal *ARQUITECTURA*, published by the Colegio Oficial de Arquitectos de Madrid.

Nieto Sobejano Arquitectos was founded in 1985 by Fuensanta Nieto and Enrique Sobejano and has offices in Madrid and Berlin. Along with being widely published in international magazines and books, the firm's work has been exhibited at the Biennale di Venezia in 2000, 2002, 2006, and 2012, at the Museum of Modern Art (MoMA), New York, in 2006, at the Kunsthaus in Graz in 2008 and at the MAST Foundation in Bologna in 2014.

They are the recipients of the 2007 National Prize for Conservation and Restoration of Cultural Heritage and the 2010 Nike Prize issued by the Bund Deutscher Architekten (BDA), as well as the Aga Khan Award for Architecture (2010), the Piranesi Prix de Rome (2011), the European Museum of the Year Award (2012), the Hannes Meyer Prize (2012), AIA Honorary Fellowship (2015), the Alvar Aalto Medal (2015) and Gold Medal of Merit in the Fine Arts (2017).

SIMONA OTTIERI

Simona Ottieri obtained her degree in Architecture in 1997, followed by a European Union Master's degree in the restoration and conservation of new cultural heritage buildings. She has a PhD in materials engineering from the Federico II University in Naples, and has headed the workshop at Gambardellarchitetti since 2003. She has been successful in a range of international competitions. Her works have been published in various books and reviews, and she was invited to exhibit in the Italian Pavilion at the last two editions of the Biennale di Architettura di Venezia.

CARME PIGEM

Rafael Aranda, Carme Pigem and Ramon Vilalta completed their studies in architecture at the School of Architecture in Valles (Escola Tècnica Superior d'Arquitectura del Vallès, or ETSAV) in 1987, and founded their studio, RCR Arquitectes, in their native city of Olot, in the Spanish province of Girona, the following year. They attribute their early success to a first prize victory in a 1988 competition sponsored by the Spanish Ministry of Public Works and Urbanism, in which they designed a lighthouse in Punta Aldea by pondering the essence of the typology, a fundamental approach that would resonate throughout all of their future works.

This achievement allowed them to explore their distinctive ideas of architecture, informed by place and their own sensitivities, resulting in winning commissions, many of which were undertaken in Catalonia. It is more recently that they have received international accolades and ventured beyond the Spanish borders with projects in other European countries. Aranda, Pigem and Vilalta have participated in important exhibitions including the III Salon International de l'Architecture in Paris in 1990; the Venice Biennale of Architecture 2000, 2002, 2006, 2008, 2012, 2014 and 2016; *MoMA's On-Site: New Architecture in Spain*, New York, 2006; *Global Ends* at Toto Gallery MA in

Tokyo, 2010; and *RCR Arquitectes. Shared Creativity* in Barcelona, 2015 and Madrid, 2016.

GUENDALINA SALIMEI

Guendalina Salimei is an architect and teaches at the Faculty of Architecture at La Sapienza University in Rome. She founded T-studio, which has won numerous Italian and international awards, including the Premio Roma Architettura award in 2002 , the XII and XIV Architecture Triennial in Sofia, the Selinunte Architecture Prize in 2014, the Pertica Prize – Oscar della città di Roma in 2015 and the Premio all'Urbanistica from UrbanPromo in 2016. T-Studio has participated in many exhibitions, in particular the VII, X XI XII XIII Biennale di Venezia, the III Biennale in Beijing, the UIA in Tokyo, and curated the Epicentro Pavilion at the XIII Biennale di Architettura in Venice. T-studio has been working for over 20 years both in Italy and abroad. The firm focuses mainly on architectural, urban, and environmental design. It has conducted research into the complex relationships that arise between project construction and intervention in built-up areas and natural environments. T-studio places great importance on the social and economic history of the areas in which it works, taking care to ensure that new architectural design approaches are not disconnected from awareness of the local habitus.

MARELLA SANTANGELO

Marella Santangelo is Associate professor in Architectural and Urban Composition at the Architectural Department of Federico II University in Naples. She is a member of the College of Professors for PhD studies in architecture, is head of the DIARC Advisory Board, member of the Advisory Board and Commission at Scuola Politecnica and Basic Sciences. She is also a member of the Department Administrative Board at DIARC, and the Department Group Coordinator. Since 2018, she has been a member of the Steering Committee of the National Conference of Delegates for Prison University

Courses, the Conference of Deans of Italian Universities, and in 2021 was appointed as a member of the Ministerial Commission for Prison Architecture by the Minister of Justice. She graduated from Naples University in 1988 in Architectural Design, under Alberto Samonà, winning the Corsicato prize with her thesis in 1989. In 2016 she taught as visiting professor at the Faculty of Architecture, Design and Urbanism (FADU) at the University of Buenos Aires. She is Scientific Director for several collaboration projects with the Secondigliano, Poggioreale, and Femminile di Pozzuoli prisons, and is Superintendent of the Campania Regional Administration and Protocol of Understanding between the Ministry of Justice, Department of Prison Administration and the Department of Architecture at the Federico II University in Naples.

MARIA ALESSANDRA SEGANTINI

Graduated at IUAV in Venice, Maria Alessandra Segantini is an architect and an educator interested to investigate through design the socio-political and environmental urgencies of the contemporary times. Since 1994, she leads, with Carlo Cappai, the design practice C+S Architects, with offices in London and Treviso. Together with C+S, she has designed and built several buildings, public spaces and master plans which deserved prizes and mentions. C+S Architects work on urban regeneration and urban development projects, buildings and products with particular attention to social, economic and environmental sustainability. Author of articles, papers and books on architectural theory and history, Segantini was invited to exhibit in the 15th Venice Architecture Biennale, at the MoMA in NYC and has been a visiting professor at the MIT and Syracuse University. Her research and design on school buildings has contributed to redefine the Italian codes.

BENEDETTA TAGLIABUE

Benedetta Tagliabue studied architecture at the IUAV and currently acts as director of the international architecture firm Miralles Tagliabue EMBT, founded in Barcelona in collaboration with Enric Miralles in 1994 and opened its office in Shanghai since 2010. She is also the director of the Enric Miralles Foundation, founded in 2011, whose goal is to promote experimental architecture in the spirit of her late husband and partner Enric Miralles. Her studio works in the fields of architecture, design of public spaces, rehabilitation, interior and industrial design. Following a poetic architecture – always attentive to its context – she has won international awards in the fields of public space and design. Among her most notable urban scale projects are Santa Caterina Market in Barcelona, the New Scottish Parliament in Edinburgh, the Diagonal Mar Park in Barcelona, the University Campus of Vigo, the public spaces of the large area of revitalization of HafenCity in the Port of Hamburg, the Park of Colours in Mollet del Vallès and the Gas Natural Building in Barcelona. Her first project in Asia was the Spanish Pavilion at Expo 2010 Shanghai China which was awarded the prestigious RIBA International Best International Building of 2011 award. In academia, Benedetta has been a visiting professor at Harvard University (2012), Columbia University (2010) and Barcelona ETSAB (2002 – 2008), lecturing regularly at architecture forums and universities. In 2004 she received an honorary doctorate from the Faculty of Arts and Social Sciences, Edinburgh Napier University, Scotland.

MONICA TRICARIO

Monica Tricario was born in Milan in 1963. After graduating from Politecnico di Milano, from 1990 to 1996, she worked with Gregotti Associati in the development of the Pirelli ex-industrial site for the Bicocca area in Milan and several other projects and constructions linked with these interventions. In 1996, with Francesco Fresa, Germán Fuenmayor and Gino Garbellini, she founded the international architectural firm, Piuarch, based in Milan. Piuarch is a collective whose power and strength lies in its plurality. This cohesion is based on different backgrounds and personalities which guarantee a multi-faceted approach to work. Piuarch creates office and retail buildings, residential complexes and urban renewal projects with constant attention paid to the values of environmental quality and the relationship with the context. Piuarch is internationally known for its collaboration with several major international fashion brands, with whom it has experimented in projects aimed at social issues. Winner of the 2013 Italian Architect of the Year prize, the studio has been featured in numerous publications and dedicated monographs.

PATRICIA VIEL

Patricia Viel is an architect of French origin. She graduated in architecture from Politecnico University in Milan in 1987, and began working with Antonio Citterio in 1986. In 2000 she co-founded the Antonio Citterio Patricia Viel architectural and interior design firm which mainly focuses on the integration of architecture in urban contexts. Patricia Viel is head of the architectural and design projects and is also general manager. The firm works all over the world creating complex projects in a wide range of interventions, working in synergy with a qualified network of specialised professionals. From 2005 to 2012, Patricia Viel was a member of the Board of Advisors of InArch, the Istituto Nazionale di Architettura in Milan. In addition to her professional career, Patricia Viel also takes part in numerous conferences and seminars in Italy and abroad.

PAOLA VIGANÒ

Paola Viganò, architect and urban designer is a full tenure professor in Urbanism at the IUAV in Venice. She has been visiting professor in Europe and abroad (KU Leuven, Louvain-la-Neuve; EPFL Lausanne; Aarhus School of Architecture;

Harvard GSD) and is the Urbanism
doctoral research coordinator at IUAV,
and member of the Executive and
Educational Boards of the European
master course in Urbanism.
She is on the Scientific Committee
of the École Nationale Supérieure
d'Architecture et de Paysage in Lille
and the École Nationale Supérieure
du Paysage of Versailles.
In 2013 she was appointed Chaire
Francqui at UCL at Louvain la Neuve.
Finalist in 2010, she later won the
Grand Prix de l'Urbanisme et de l'Art
Urbain in 2013.
In 1990, she founded a firm with
Bernardo Secchi, winning several
international awards. Their most
recognised projects include the new
Theatre Square and Spoornoord Park
in Antwerp; a public spaces project
in Mechelen, and the cemetery and
Grote Markt in Kortrijk.

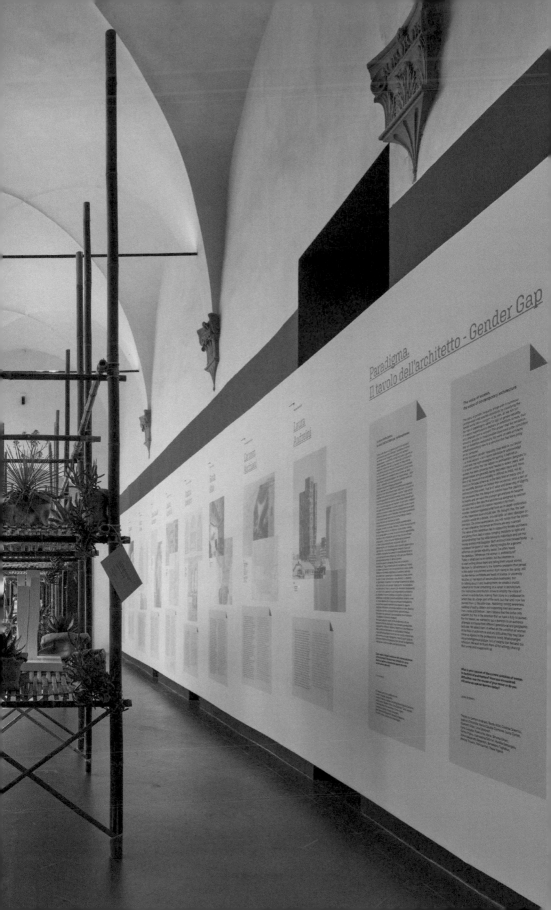

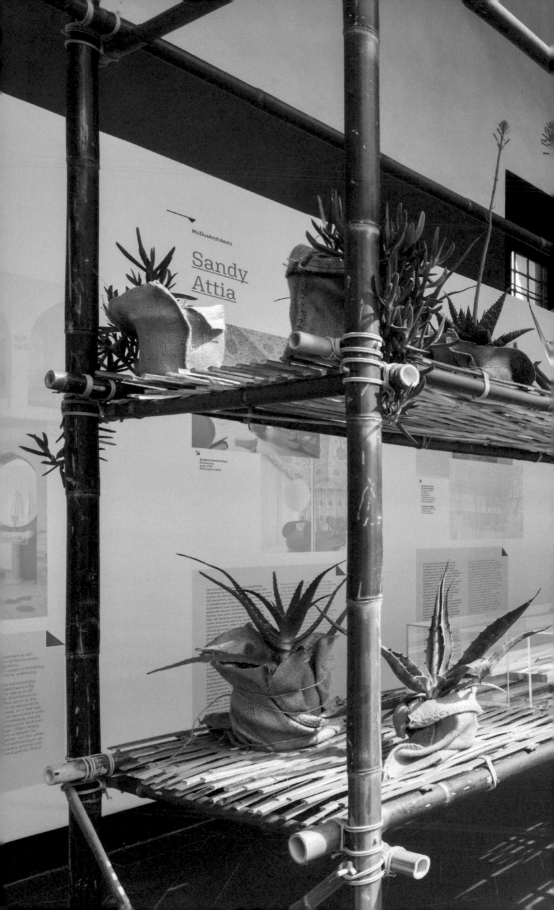

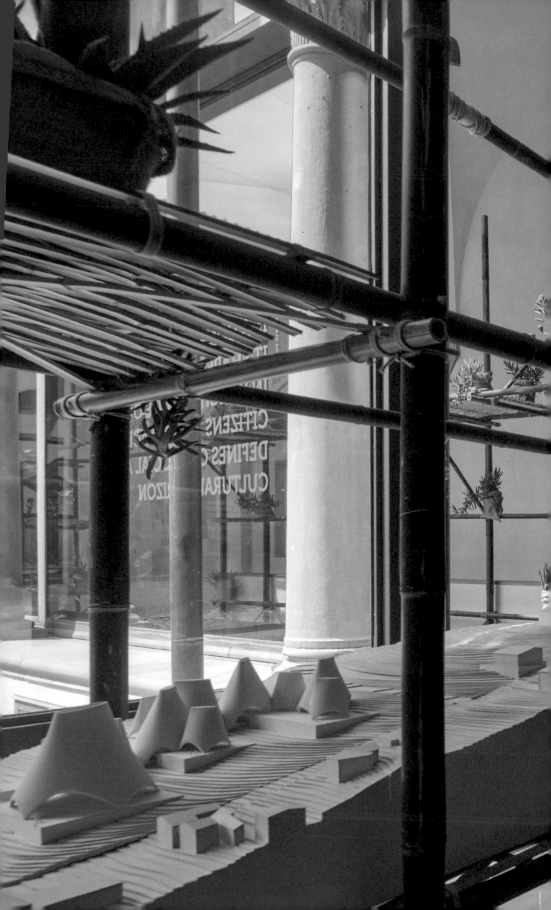

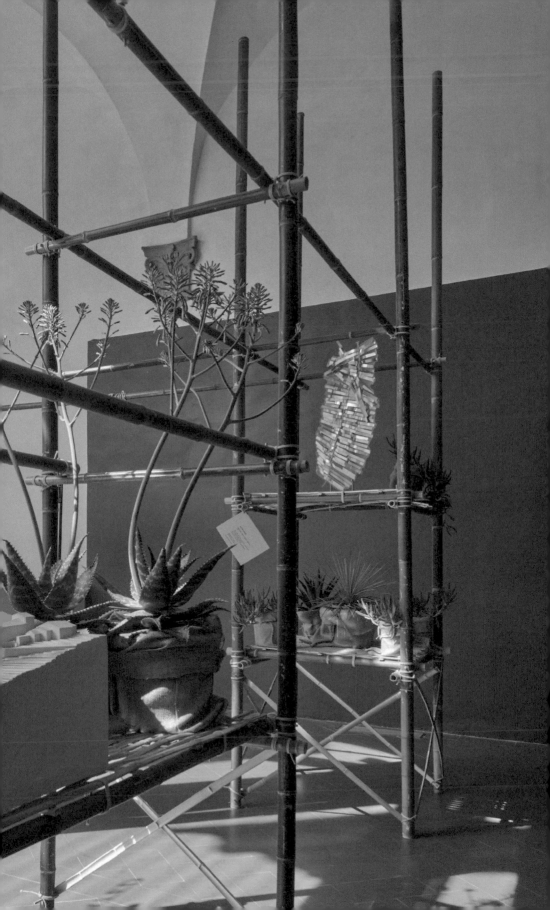

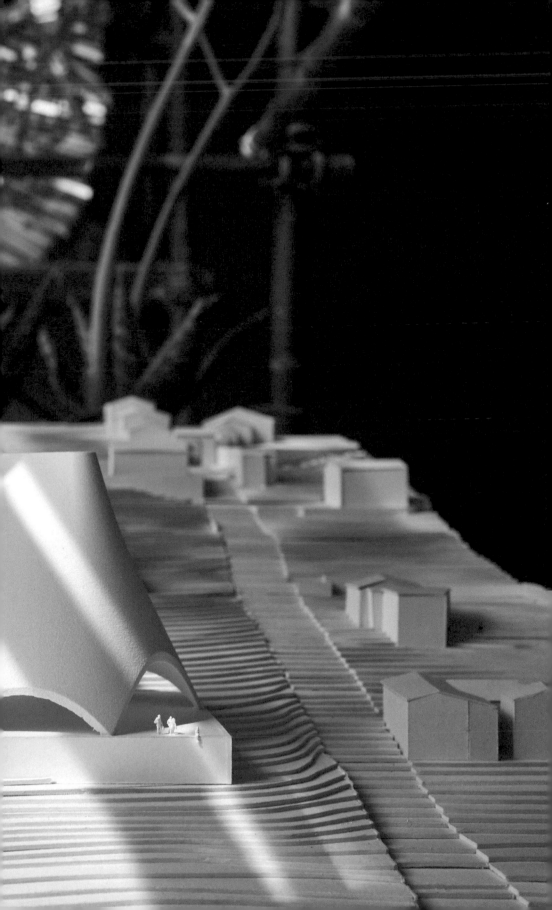

Forma Edizioni
Florence, Italy
redazione@formaedizioni.it
www.formaedizioni.it

EDITORIAL DIRECTOR
Laura Andreini

EDITORIAL STAFF
Maria Giulia Caliri
Livia D'Aliasi
Beatrice Papucci
Andrea Benelli

GRAPHIC DESIGN
Deepa Parapatt

PHOTOLITOGRAPHY
LAB di Gallotti
Giuseppe Fulvio
Firenze, Italia

TEXTS
© the authors

TRANSLATIONS
Katy Hannan

SET-UP PHOTOGRAPHS BY
© Neri Casamonti

Part of the material published in this book
was taken from the article "Open Dialogue:
Gender Gap" by Laura Andreini in *area* no. 173,
November-December 2020, pp. 4-17.

PARADIGMA.
IL TAVOLO DELL'ARCHITETTO –
GENDER GAP

AN EXHIBITION PROMOTED BY
Comune di Firenze

CONCEPT AND SCIENTIFIC DIRECTION
Sergio Risaliti

CURATED BY
Laura Andreini

SCIENTIFIC COORDINATION
AND ORGANIZATION
Francesca Neri – MUS.E
Luca Puri
Andrea Benelli, Beatrice Papucci

COMMUNICATION
MUS.E
Costanza Savelloni

EDUCATION DEPARTMENT
MUS.E

PRESS OFFICE
Elisa Di Lupo, Comune di Firenze
Lea Codognato e Caterina Briganti,
Davis & Co.

VISUAL IDENTITY
Concept: FRUSH design studio
Realization: Dania Menafra

GRAPHIC PRINTS ON DISPLAY
Fotolito La Progressiva

TRANSLATIONS
Alicia Fischer
NTL – Il Nuovo Traduttore Letterario

CONDITION REPORT
Silvia Fiaschi

INSURANCE
MAG - Jlt

SECURITY
REAR Società Cooperativa

LIGHTING INSTALLATION
Vannetti Andrea

HANDLING AND ARTWORKS PREPARATION
APICE Firenze S.R.L.

GRAPHIC AND SET-UP PROJECT
Laura Andreini / Archea Associati
Laura Maltinti, Mirco Donati, Giacomo Toncelli

REALIZATION
Bambuseto

GREEN SETTING
Vannucci piante

THANKS TO
Dario Nardella, Mayor of Florence
Tommaso Sacchi, Councilor of Culture
Matteo Spanò, President MUS.E

Andrea Batistini, Andrea Bianchi,
Mariella Carlotti, Monica Consoli,
Gabriella Farsi, Eva Francioli,
Roberto Gabucci, Antonella Nicola,
Cecilia Pappaianni, Silvia Penna,
Stefania Rispoli, Paolo Sani,
Lorenzo Valloriani, Valentina Zucchi

This volume was printed in September 2021
by CAPPELLI Arti Grafiche, Sesto Fiorentino (FI)